FLOWER PAINTINGS

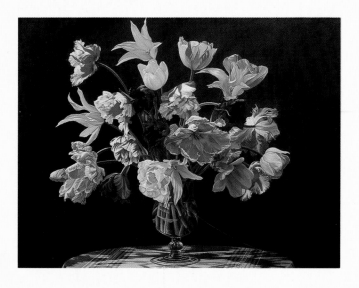

FAWCETT COLUMBINE · NEW YORK

A Fawcett Columbine Book
Published by Ballantine Books

First published in Great Britain in 1988 by
Pavilion Books Limited
196 Shaftesbury Avenue, London WC2H 8JL
in association with Michael Joseph Limited
27 Wrights Lane, Kensington, London W8 5TZ

ISBN: 0-449-90316-8

Manufactured in the United States of America

First American Edition: August 1988

10 9 8 7 6 5 4 3 2

FOREWORD

Flowers have inspired artists from the beginning of time – they are the perfection of color and form, the essence of creativity. For as long as the human hand and eye have striven to honor the natural world, or simply to record it, flowers and painting have enjoyed a particularly poignant relationship. Flowers fade and die all too quickly, and the painter alone can grant the flower immortality.

The purpose of flower painting is above all to give pleasure. We can admire not only the painter's eye for detail and skill at composition, but we enjoy the love of beauty that invariably suffuses such work. Flowers are equally the amateur artist's favorite subject. Was ever an image more doodled than the daisy?

Whatever the season, flower paintings provide a universal language for happiness or sympathy, gratitude and congratulations. Whether you need to celebrate or to console, the right flower painting can match the occasion. With examples from the Victorian to the contemporary, these colorful cards offer a perennial bouquet.

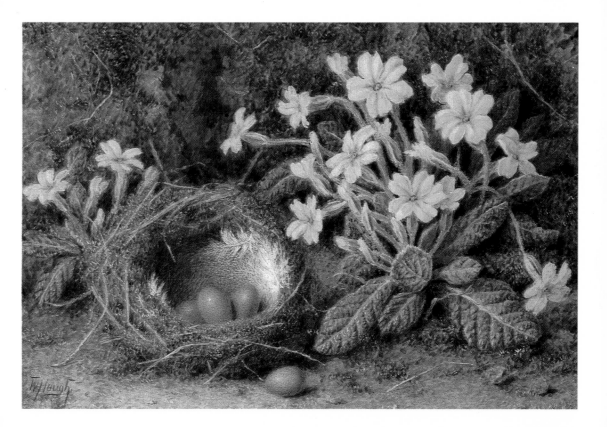

FAWCETT COLUMBINE · NEW YORK

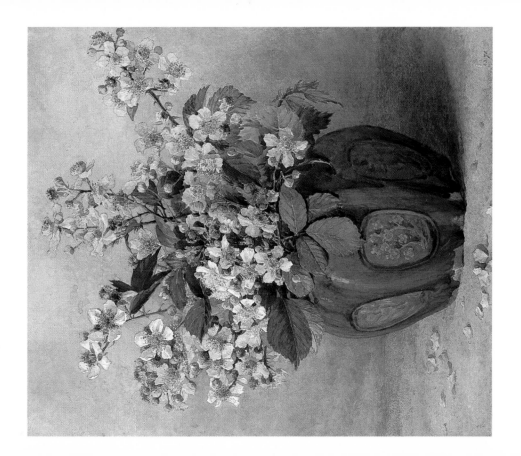

MARY E. BUTLER (Fl. 1867-1912)
Blackberry Blossom
VICTORIA & ALBERT MUSEUM, LONDON /
BRIDGEMAN ART LIBRARY

FAWCETT COLUMBINE · NEW YORK

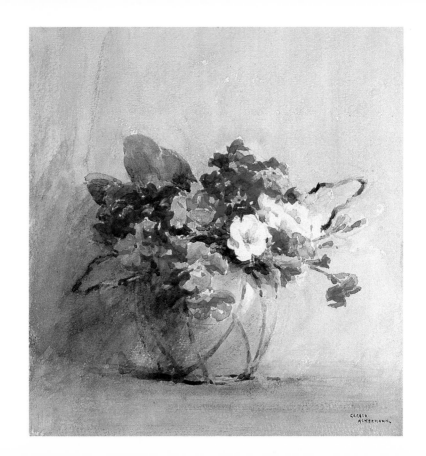

ARTHUR GERALD ACKERMANN (1876-1960)
Polyanthus
COURTESY OF CHRIS BEETLES LTD, ST JAMES'S, LONDON

FAWCETT COLUMBINE · NEW YORK

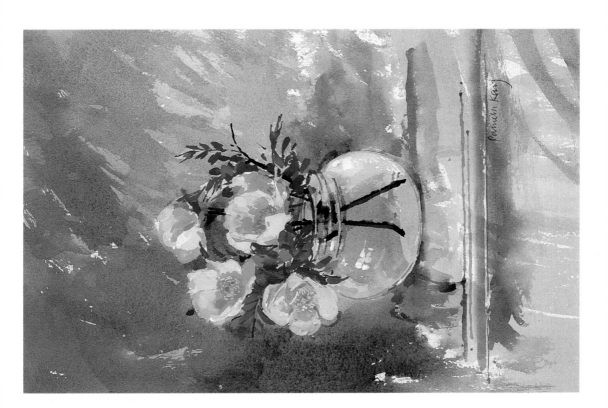

FAWCETT COLUMBINE · NEW YORK

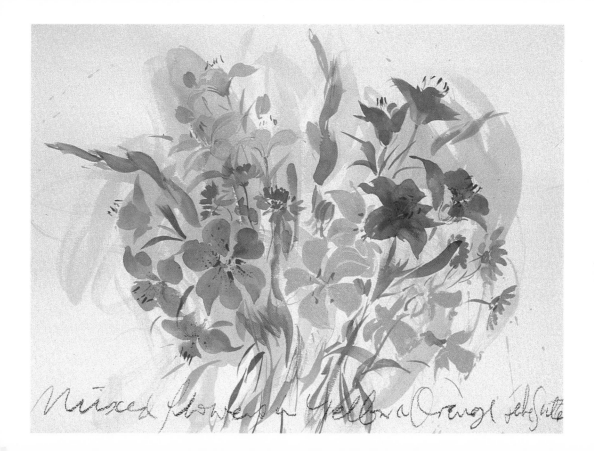

Mixed flowers in Yellow & Orange Jeff Gutcheon

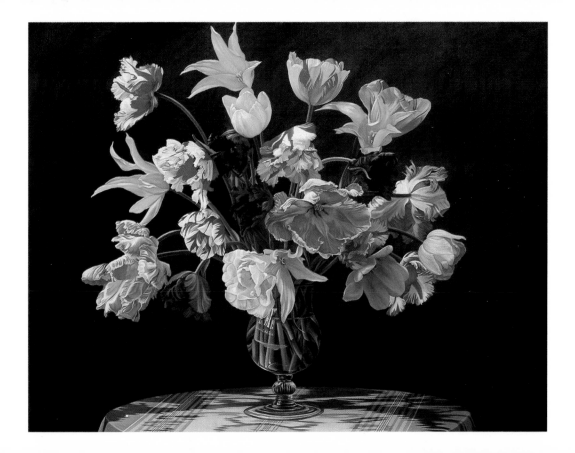

Nigel Waymouth©
Tulips

FAWCETT COLUMBINE · NEW YORK

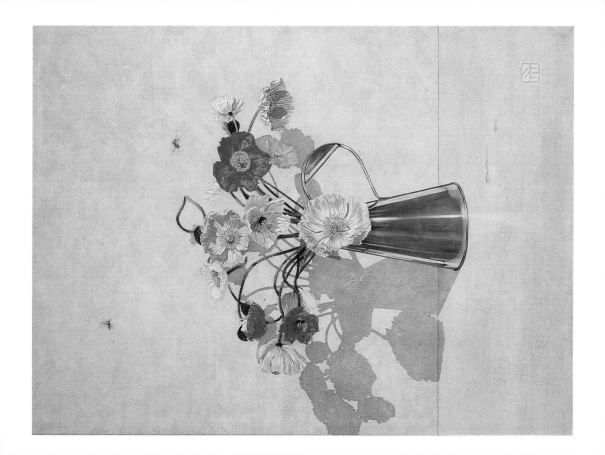

FAWCETT COLUMBINE · NEW YORK

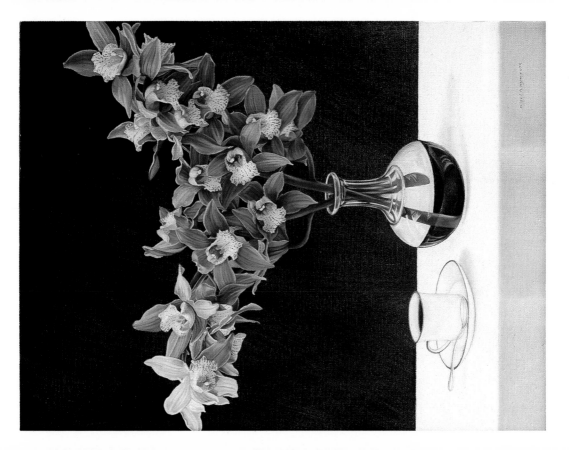

FAWCETT COLUMBINE · NEW YORK

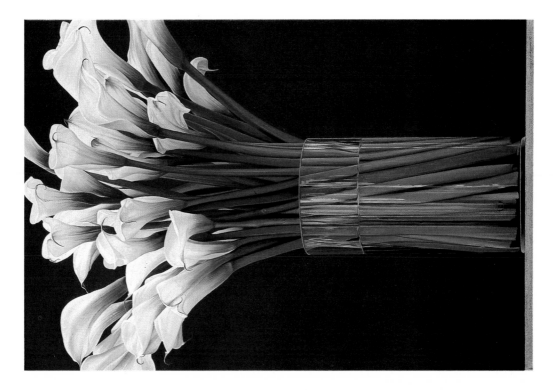

NIGEL WAYMOUTH©
Arum Lilies

FAWCETT COLUMBINE · NEW YORK

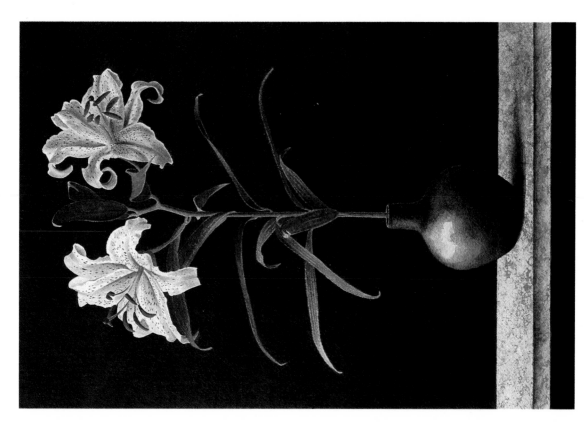

FAWCETT COLUMBINE · NEW YORK

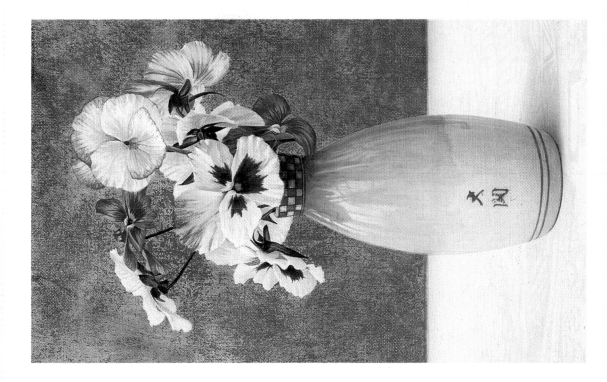

FAWCETT COLUMBINE · NEW YORK

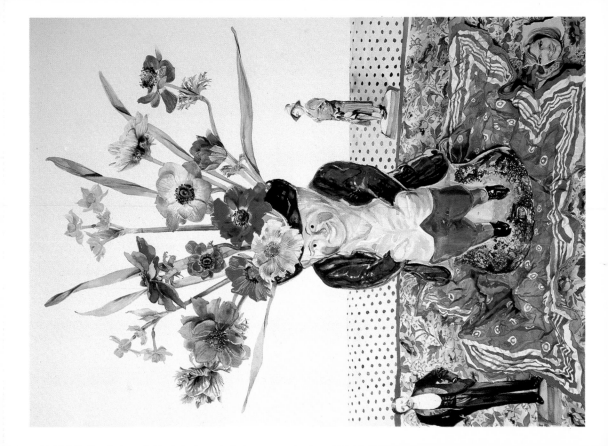

FAWCETT COLUMBINE · NEW YORK

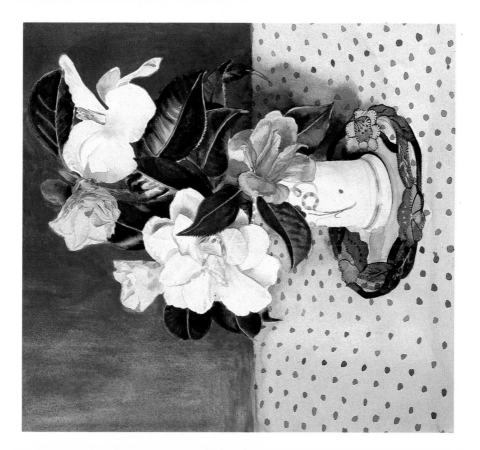

FAWCETT COLUMBINE · NEW YORK

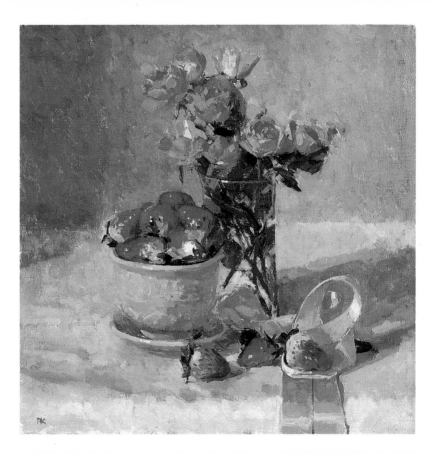

PAMELA KAY ©
Strawberries in a Chinese Bowl with Roses and a Pink Ribbon
COURTESY OF CHRIS BEETLES LTD, ST JAMES'S, LONDON

FAWCETT COLUMBINE · NEW YORK

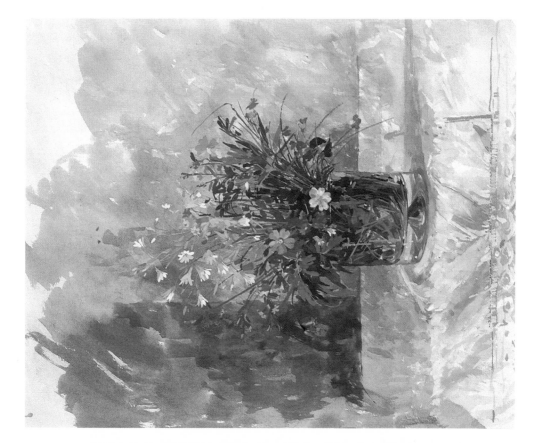

PAMELA KAY ©
Glass of Spring Flowers
COURTESY OF CHRIS BEETLES LTD, LONDON

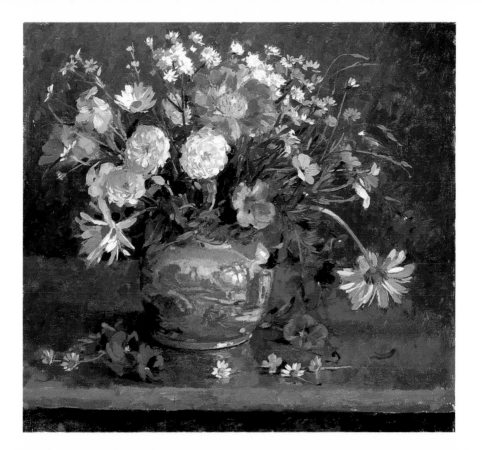

FAWCETT COLUMBINE · NEW YORK

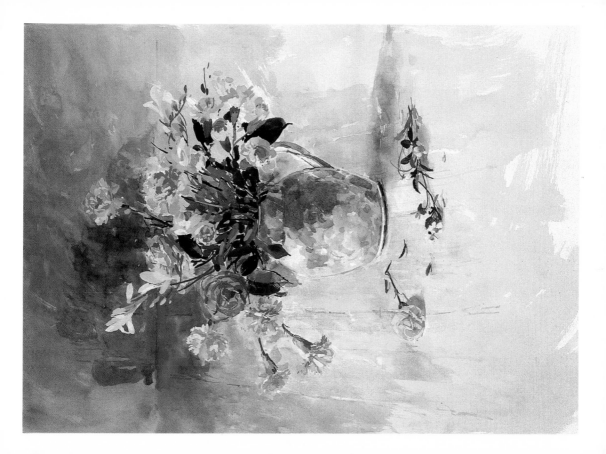

FAWCETT COLUMBINE · NEW YORK

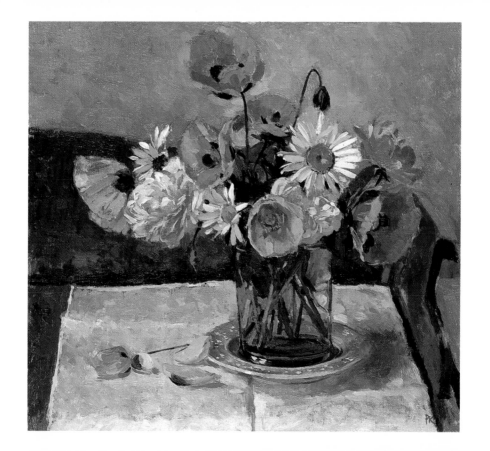

PAMELA KAY ©
Poppies, Roses and Daisies in a Glass
COURTESY OF CHRIS BEETLES LTD, ST JAMES'S, LONDON

FAWCETT COLUMBINE · NEW YORK

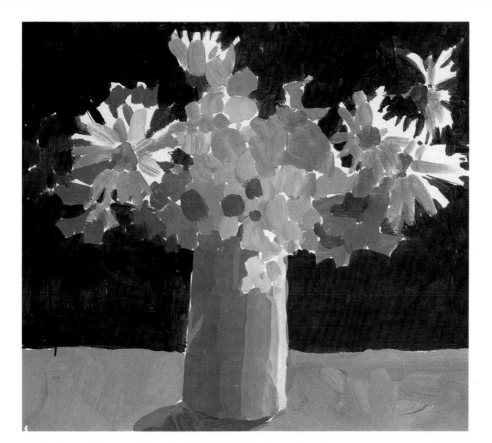

FAWCETT COLUMBINE · NEW YORK

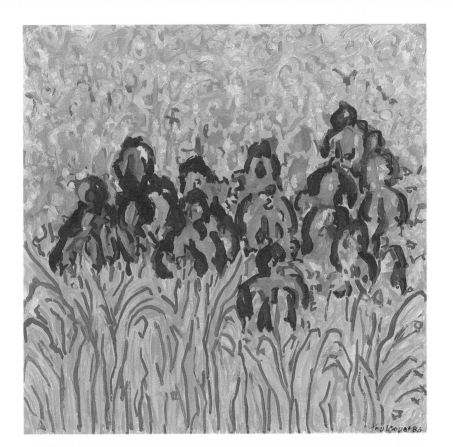

JEAN-MARIE TOULGOUAT ©
Summer Flowers, Giverny
COURTESY OF FRANCIS KYLE GALLERY, LONDON

FAWCETT · COLUMBINE · NEW YORK

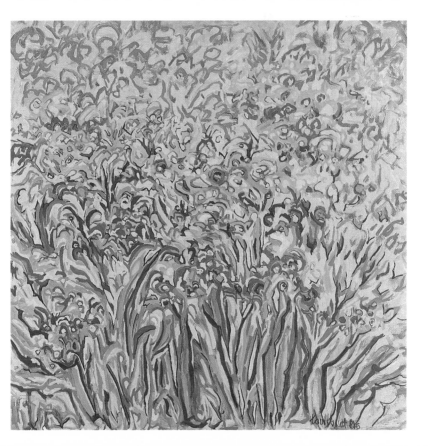

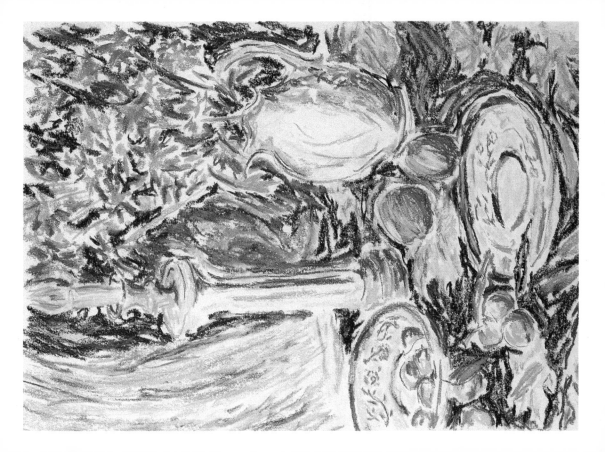

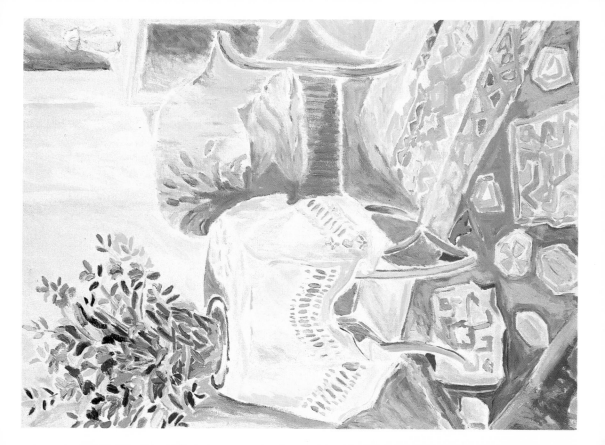

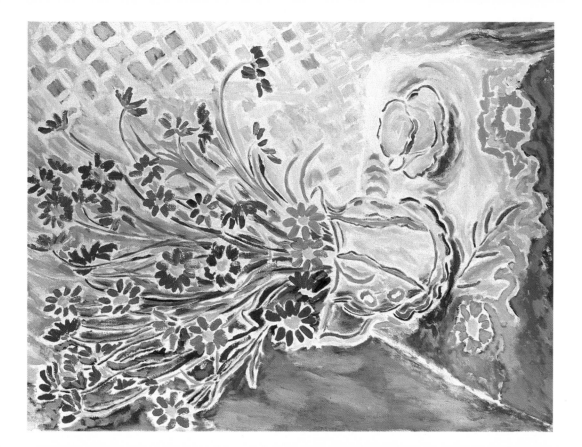

HUGH BARNDEN ©
Yellow Light
COURTESY OF FRANCIS KYLE GALLERY, LONDON

FAWCETT COLUMBINE · NEW YORK

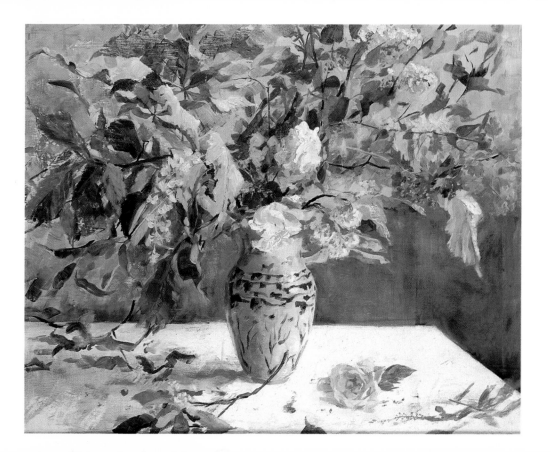

FAWCETT COLUMBINE · NEW YORK

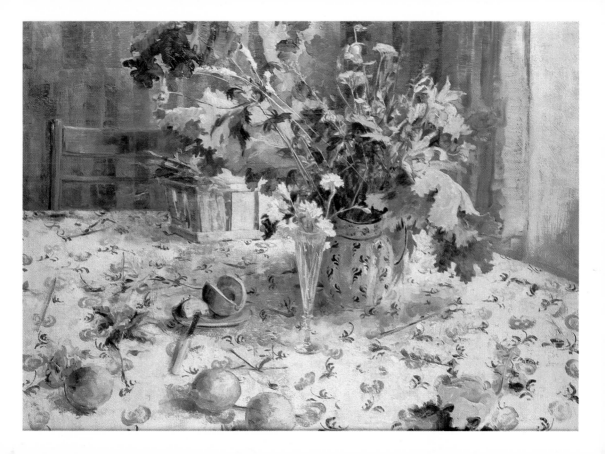

FAWCETT COLUMBINE · NEW YORK

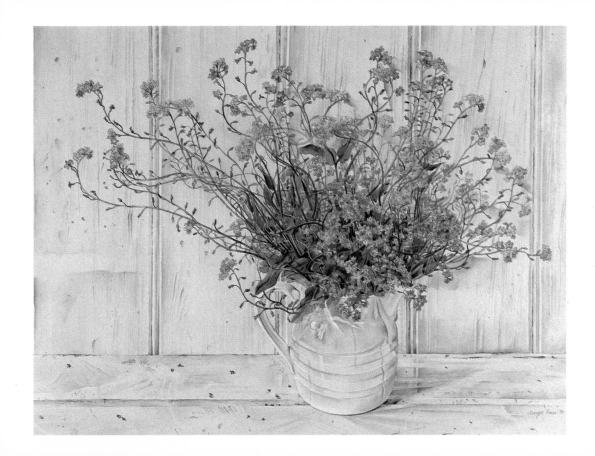

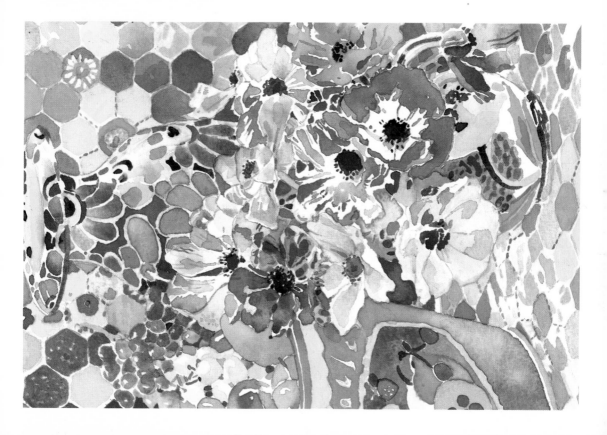

NICOLA GREGORY ©
Flowers

FAWCETT COLUMBINE · NEW YORK